My Dear Anne

Here is a momento of all our wonderful time together on the West Coast Trail in August of 1996.

Your loving Dad

TIMELESS *Shore*

Published by Bayeux Arts Incorporated
Suite 240, 4411 – Sixteenth Avenue N.W.
Calgary, Alberta, CANADA T3B 0M3

Photography by George Allen
Text by George Allen
Design by George Allen

Printed and bound in Canada by
Friesen Printing, Altona, Manitoba

Canadian Cataloguing in Publication Data

Allen, George, 1955 –
Timeless Shore

ISBN 1-896209-06-8
1. West Coast Trail (B.C.) — Pictorial works
2. West Coast Trail (B.C.) — Description and travel I. Title.
FC3845.W47A4 1994 971.1'2
C94-910410-8 F1089.W47A4 1994

George Allen

TIMELESS *Shore*

CANADA'S **WEST COAST TRAIL**

BAYEUX

to Fran, Sam & Lindsay

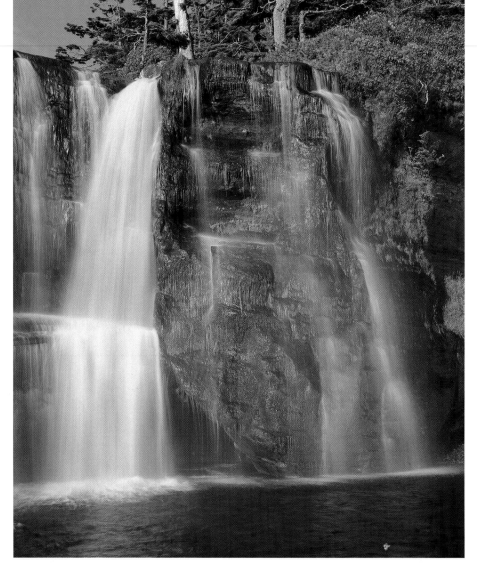

KM.25 — TSUSIAT FALLS.

I NTRODUCTION

When I first travelled the West Coast Trail in the summer of 1971, I had never before been on an overnight backpacking trip. A teacher of mine had aroused my curiosity about this stretch of coastline earlier that spring, and my parents, understanding the value of such formative experiences, also offered words of encouragement. With these inducements, and in the company of a few friends, I set off on a journey on foot that to this day affords one of the world's finest recreational experiences.

Early in its modern life, little had been done to upgrade the trail, except some brush clearing and route marking. There was little in the way of boardwalk, ladder, or bridge repair. It is not surprising that during our first day on the east end of the trail we strained and sweated to travel 7 kilometres. Exhausted, we bedded down for the night in the middle of the trail under a plastic sheet and the raven blackness of the forest canopy.

The next day we pushed on to Camper Creek. Beyond Camper, we had to wade across most streams. Forest travel was hampered by fallen trees and extended stretches of mud, the result of little or no board-walk. We felt that we were taking our lives into our hands as we climbed up and down the ladders of Logan Creek or crossed the old suspension bridge at Tsocowis Creek. To cross the Nitinat we relied on the good-will of passing boats. We also risked losing a few fingers while riding on the last remaining cable car at the Darling River. It was, at times, a muddy, slippery and tiring experience, but eight days later we emerged at

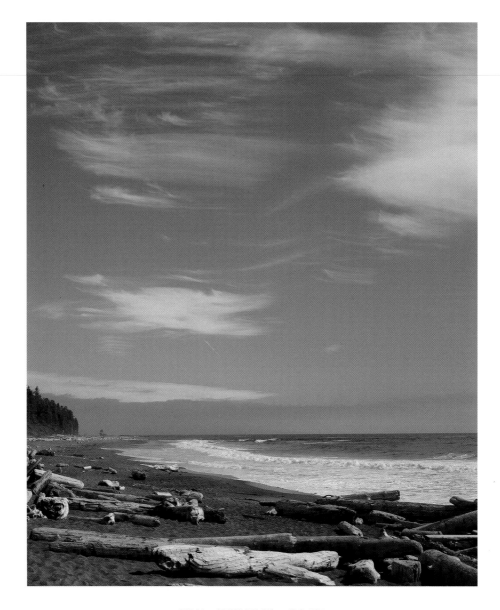

KM. 36 — 'LONG BEACH' — CLO-OSE

8

Pachena Bay knowing, with youthful enthusiasm, that we had completed a truly glorious adventure.

The following year three of us went back again. At Camper Creek, a deluge of rain turned the normally placid brook into a raging torrent, trapping us on the 'wrong' side of the river for two days. Never were we more grateful than for the shelter offered by the disheveled remains of what once stood as a linesman's cabin. When the river finally subsided we were able to set off west on the coastal shelf, determined to explore some of the alternate beach routes that we had missed the previous year.

On the trail again in the late 1970's, I was left with other impressions. There was the shipping container that had washed ashore and broken up on Dare Beach, dotting the pristine sand with transistor radios, yet another victim of this wild shore. There was the fresh salmon baked over an open beach fire at Clo-ose, and the live crab bought at Nitinat Narrows and eaten beneath the backdrop of Tsusiat Falls.

By the early 1980's, the hand of Parks Canada was evident in the changes made to cope with increasing numbers of hikers. The West Coast Trail had gained a reputation that was attracting people from around the world. Many kilometers of boardwalk were rebuilt and new cable cars were installed. New bridges were in place, notably the spectacular suspension bridge that crosses Logan Creek. I remember too, one sublime evening spent on the broad beach at the Cheewhat River where, beyond the surf, killer whales cruised the waters of the bay.

In 1992, a quota system was introduced in an attempt to preserve the spirit of the trail for those who venture along it. Thus, there still exisits much of what always made the adventure a memorable experience.

For all the improvements that have made travel marginally safer, and despite the great increase in the number of users, the trail experience remains immensely satisfying on a personal and physical level. True to the principle of all wilderness experiences, the rewards have to be earned; they are intrinsic, not abstract. Perhaps, over time, I have come to see rewards in the shapes of trees and the textures of rocks, in the vagaries of a fog bank or in the fluid images of a late night fire fanned by a whispering breeze.

Looking back, one also senses the rhythms of this trail. There is the rhythm of walking; the roots, the logs, the rock shelf and the sand imposing their own cadence. The world seems somehow a different sort of place at the end of a long day's walk. One becomes 'body conscious' as the mind turns to weary arches, worn heels, and knees that have suffered the slings of ten thousand steps. Shoulders suffer under the burden of one's possessions which, no matter what the weight, never seem meager enough. Each day ends with the reward of relaxation and release, though the daily rituals of cooking food, erecting shelter and getting water still remain. By next morning, the routine is set to repeat itself, and so it goes each day for a week or so along this stunning stretch of North Pacific coastline. Our small daily necessities become an instructive metaphor for society's larger necessities.

As the days pass, the pack on one's back lightens bit by bit (some may say bite by bite); one moves more perceptively through the landscape and begins to feel the 'atmosphere' of the place, to observe with a sense of wonder the environment shifting from forest to beach to shelf. The cycles of shifting light and cloud and wind and their effect on the personality of the sea and trees create remarkable states of nature

(and states of mind). One doesn't just drive up to the West Coast Trail to watch the sunset, then turn and go home. One sets out to live in a different world for a while.

As the years pass, one can almost feel the creeping 'jungle' dissolving the path that runs through it, adding its patina to that which lies within it. Man-made structures rot quickly in the moist air. Boardwalks and ladders that were new only a few years ago have rotted and broken. The sand shifts under the onslaught of winter storms. Rivers flow to the sea through new channels. The forest slips off the lip of canyon walls and beach bluffs. Memories also change over time. One's sense of what the journey was, and is, shifts, becomes embellished and shaded, with each visit. There is an undeniable aesthetic resonance in the tangible and visible environment and in the revelations of personal experience.

The book traces the trail's route from west to east, starting at Pachena Bay near Bamfield, and ending at the Gordon River near Port Renfrew, some 77 kilometres to the east. Generally, the West Coast Trail is flat. At its highest point, on the north side of Port San Juan, it rises to only about 200 metres. Most travel is along the beach or at the 25 metre height of the cliffs that rim many stretches of the coastal route. From Pachena Bay to Pachena Point Lighthouse a wide path passes through old growth forest, with gentle grades reflective of its earlier use as primary access to the lighthouse. Soon after Pachena Point, the trail drops to the beach which it then follows most of the way to the Klanawa River. Here, one finds a first taste of inter-tidal life, sculptured boulders, logs piled against the brim of the beach by winter gales, and the respite of streams that cut down to the sea's edge. Between the major crossing at the Klanawa and the crossing by

boat at Nitinat Narrows are some of the finest beaches along the trail, broken by headlands, and highlighted by Tsusiat Falls and 'Hole-in-the-Wall' at Tsusiat Point. From the Nitinat to Carmanah Point Lighthouse the path meanders on and off the beach and shelf, but its focal point remains the unique beachscape, dunes, and riverine environment around the Cheewhat. East of the lighthouse one arcs across the broad expanse of the beach at Carmanah, then on to the sea stacks of Bonilla Point and the steep sand at Vancouver Point. The beach ends at Walbran Creek, one of the most beautiful watercourses to transect the trail. East of Walbran one remembers the challenging ladder ascents and descents into and out of Walbran, Logan, Cullite, Sandstone, and Camper Creeks, all interspersed with bog, mud and knotted roots. From Camper Bay to the trailheads at Thrasher Cove or the Gordon River there is the option of travelling through the forest or traversing the sections of sandstone shelf that offer up a mix of surge channels, sculptured headlands, and a Goliath's playground of stone blocks.

The photographs in this book are dedicated to the experience, as well as the appearance, of this journey on foot. There are the sweeping vistas and the glorious sunsets, but there is also the detail of small views. There are ladders that seem to rise endlessly into some green heaven, exquisite crab shells littering the sand, and burning fires to warm the night. Then there are the people one meets along the way, with accents from around the world and expressing their distinctiveness in the way a pack is loaded or a hat is crumpled. My hope is that through these images you will sense something of the deep pleasure of this place.

George Allen

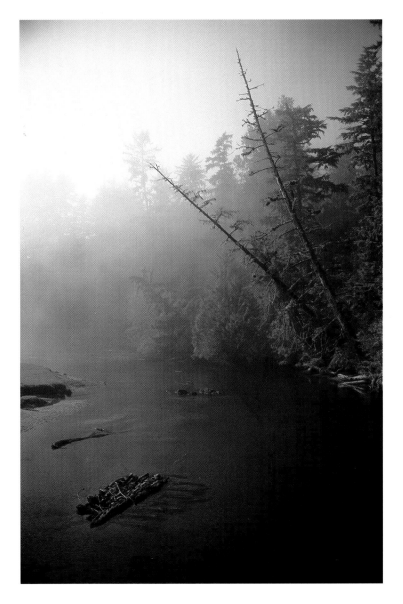

KM.36 — THE CHEEWHAT RIVER.

13

14

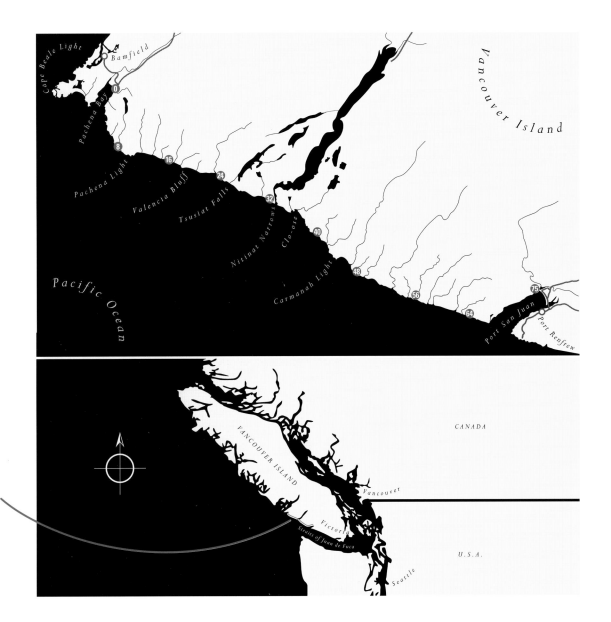

Cape Beale Light
Bamfield
Pachena Bay
0
8
16
Pachena Light
24
Valencia Bluff
Tsusiat Falls
32
Clo-ose
Nitinat Narrows
40
48
Carmanah Light
56
64
75
Port San Juan
Port Renfrew

Vancouver Island

Pacific Ocean

VANCOUVER ISLAND

CANADA

Vancouver

Victoria

Straits of Juan de Fuca

Seattle

U.S.A.

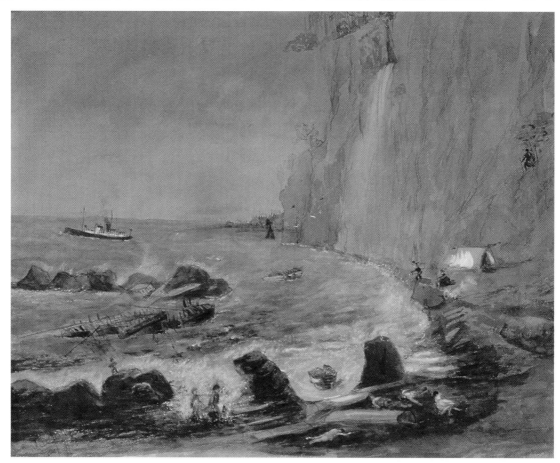

16

"TOO LATE, ALL IS OVER" — THE WRECK OF THE 'VALENCIA', KM.18 — WATERCOLOUR BY J.D. GALL, 1906.

A BRIEF HISTORY

The history of the West Coast Trail is inextricably tied to the lives of turn-of-the-century mariners and their misfortunes at the entrance to the Straits of Juan de Fuca. As shipping traffic into the ports of Victoria, Seattle and Vancouver increased through the latter part of the 19th and into the 20th century, so too did the number of ships foundering on the treacherous western shores of Vancouver Island. Driven to shore by violent storms, confused or lost in the fogs and currents off the mouth of the straits, many shipwrecks occurred between Barkley Sound and Port San Juan on the Island's coast. Indeed, these shores came to be known as the 'Graveyard of the Pacific'.

To aid navigation, the first lighthouse on Vancouver Island's west coast was built at Cape Beale, at the eastern entrance to Barkley Sound, in 1873. In 1890, a second lighthouse was built at Carmanah Point, 45 kilometres to the east. That same year a telegraph line was installed along the coast connecting Cape Beale with Victoria, 150 kilometres away, at the southern tip of Vancouver Island. A single strand of galvanized wire strung from tree to tree was to be the coast's important link with the outside world, but it was a tenacious link at best. The line was frequently grounded by branches or broken by falling trees, and it was not uncommon for it to be down for weeks at a time. For all its flaws, the line was courageously maintained by a team of linesmen, each of whom was responsible for a 40 kilometre section of the route.

Over the next 15 years shipwrecks continued to occur along the coast. Two lighthouses and a simple communications system did not establish a foolproof navigational aid. The sea remained relentless in its pounding of these remote shores. Linesmen were often pressed into service rescuing survivors from wrecks.

∞

In the black of the night of January 22nd, 1906, the pivotal event of the trail's history occurred a short distance east of Pachena Point with the tragic wreck of the American passenger steamship *Valencia*. Inbound to Victoria and Seattle from San Francisco, the ship had lost its way in poor visibility. Ocean drift also added a critical 60 kilometres of error to the ship's position as it entered the straits, with the Captain navigating by depth sounding and dead reckoning. Without any warning, the ship suddenly crashed into the shoreline rocks. The Captain immediately reversed the ship off into deep water, but soon realizing the extent of the ship's damage, he steamed back onto the shore, grounding the ship some 50 turbulent metres from the sea cliffs.

Heavy seas and brisk winds blew waves and spray over the ship. In the confusion to escape, many of the ship's lifeboats were lost at launch or in the crashing surf, taking with them the lives of many passengers. Rocket-launched rescue lines, designed to be fired onto the shore, all failed. Eventually, one of the lifeboats drifted into Pachena Bay, some 18 kilometres away, from where the survivor party followed the telegraph wire another 5 kilometres to the Cape Beale Lighthouse.

Meanwhile, another small party of people had survived the seas and made it to the beach. They managed to scale the abutting cliffs, locate the telegraph line, and travel the 4 kilometres west to the Darling River

where they found the cabin of linesman David Logan. Though the cabin was vacant at the time, the party was able to reach Logan by telephone at his home in Clo-ose, 16 kilometres to the east. Before the first party reached Cape Beale, Logan had contacted the lightkeepers who in turn notified authorities in Victoria. It had been a frightful 15 hours before the outside world found out about the wreck.

Rescue and salvage ships soon came steaming to the area. A shore party led by David Logan was also on its way from Clo-ose, but the sea continued taking its toll. The ship had been turned around and had sunk lower in the pounding swells. Some people still clung to the rigging but waves washed over the ship, eventually breaking her up and destroying any opportunity of rescue. Logan's shore party arrived too late to offer assistance to those still on board. Although several rescue vessels also arrived at the wreck site in time to see people clinging to the ship's rigging, they remained off-shore and failed to make any concerted effort to send in rescue craft. This failure later brought criticism from the Commission of Inquiry struck after the disaster. In the end, 126 of the Valencia's 164 passengers and crew perished in the wreck — 67 were lost at sea.

∞

The tragedy of the Valencia received widespread media coverage. The Commission of Inquiry recommended a variety of measures to prevent or alleviate future disasters. These included the placement of new navigational aids and the construction of a trail capable of accommodating shore-based lifesaving equipment.

That same year, 1906, a lifesaving station was built at Clonard Creek in Pachena Bay. In 1907, the station was moved into Bamfield where the Canadian Coast Guard maintains a lifeboat station to the present day.

Another shed from Bamfield was later moved back to the original site, the remains of which can still be seen.

By 1907, the Pachena Point Lighthouse was constructed a few kilometres west of the Valencia wreck site, where it stands today, active as the oldest surviving wooden lighthouse on the B.C. coast. Its huge lens still turns on a bearing that floats on a 900 lb. bath of mercury.

Construction on the West Coast Lifesaving Trail began in the spring of 1907, following the route of the earlier telegraph and telephone line. Starting at Bamfield, the trail was built 4 metres wide to the site of the Valencia's watery grave. Beyond, to Carmanah Point, the trail was narrowed to a width of 1.2 metres because of the difficult terrain. Even backed by the resources of the government, the task of constructing and maintaining a wide trail was formidable on such a wild and remote shore. Most work had to be done by hand with pick and shovel. Deep pits remain by the trailside where hardpan was dug up to surface the path. Bridges and aerial trolleys were installed to cross rivers, and cabins built every 10 kilometres: at Dare Point, Tsusiat Point, the Klanawa River, Tsocowis Creek, the Darling River, and Pachena Bay. Beyond the lighthouse at Carmanah, east toward Port San Juan, the trail was never upgraded. To this day it is the most rugged and difficult section of the West Coast Trail.

But for the lightkeepers at Pachena and Carmanah and a few other hardy souls, there is no permanent settlement on the outer coast between Pachena Bay and Port San Juan. This was not always so. Long the territory of the Nitinaht, Ohiaht and Pacheenaht natives, the area supported an active fishing and whaling economy for hundreds of years from the seasonal and permanent settlements that dotted the coast and some of the

inland lakes. Traces of the early outposts are marked as reserve lands on modern maps. Of these, the villages of Whyac and Clo-ose were the focus of most activity. During the early days of the trail, the village of Clo-ose was home to both Natives and Whites. Initially serving as a fishing outpost and base for telegraph linesmen and government surveyors, a subsequent economic base was provided by fish canneries at Brown Bay at the west end of Nitinat Lake, and within Nitinat Narrows.

Prior to World War I, Clo-ose became the target of the 'West Coast Development Company' who promoted the area as the west coast's answer to the world's great beach resorts. Their elaborate scheme, complete with grand hotel, ocean pier, boardwalk and spa, was widely promoted through ads and a glossy brochure in places as far away as Britain. The viability of the scheme was further distorted by depictions of a West Coast Highway running up to Clo-ose from Victoria and by suggestions that the CN rail line would be extended through to Nitinat Lake from the Cowichan Valley on the east side of the Island. A nucleus of about 50 people settled into the growing community, but soon the hardships of living in such an isolated place became apparent. Provisioning was at the mercy of the weather. In poor weather, supply ships would often bypass the village. Goods had to be ordered in bulk given the infrequent landings. Weather permitting, supplies would be ferried to the shore in dugout canoes and, on occasion, barges would land directly on the beach. At least one piano is known to have been delivered this way! The grand hotel of the promotional brochure and the pier, the spa, the golf course, the highway and the rail line never materialized. Nonetheless, the village appears to have become a vibrant community, boasting a store, a school, a post office, a church,

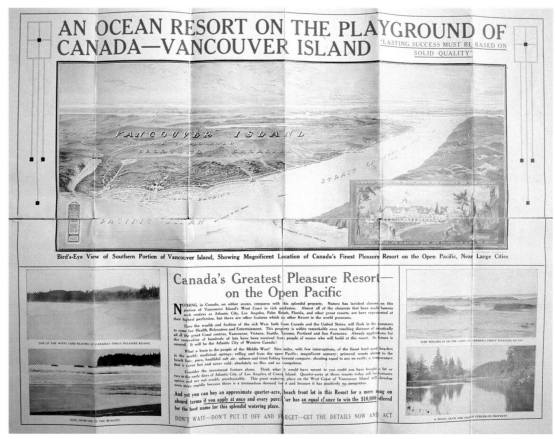

Collection of Provincial Archives of British Columbia

THE BROCHURE DISTRIBUTED BY THE 'WEST COAST DEVELOPMENT COMPANY' C.1910 TO PROMOTE CLO-OSE.

and neat and civilized homes. The optimism was short-lived, however, as events exploded a continent away.

Future aspirations were badly shaken by the onset of the First World War. Most of the men in Clo-ose left in 1915 to join the war effort. Many never returned. Clo-ose is reputed to have made the greatest per capita sacrifice of men during the war of any community in Canada. The departure of the village's men heightened the hardships of those who were left behind. Many eventually left for easier lives in Victoria and elsewhere.

Clo-ose was promoted again after the war. The local population grew to about 250 people despite the community's continued isolation. Again, this growth was short-lived. The local canneries shut down in the 1920's and people started to leave once more. Over the next few decades the population dwindled to fewer than 30 people. Although a postal service was maintained until 1963, Clo-ose was effectively abandoned by 1966. By the 1950's, new radio and radar technologies had supplanted the need for both a telegraph line and a lifesaving trail, and the route fell into disrepair.

By the 1960's a new life was emerging for the trail. In 1967, interest in the history and beauty of the area led to the idea of creating a park around the trail and in 1969, an act of the B.C. legislature permitted lands to be acquired for Pacific Rim Park. This in turn led to the incorporation of the West Coast Trail into Pacific Rim National Park in 1970.

Since gaining park status, the trail has attracted ever greater numbers of hikers from points around the world. The trail's history of survival and the struggle against the elements has been transformed into a different kind of struggle against the elements, one that speaks to the spiritual value of places like this.

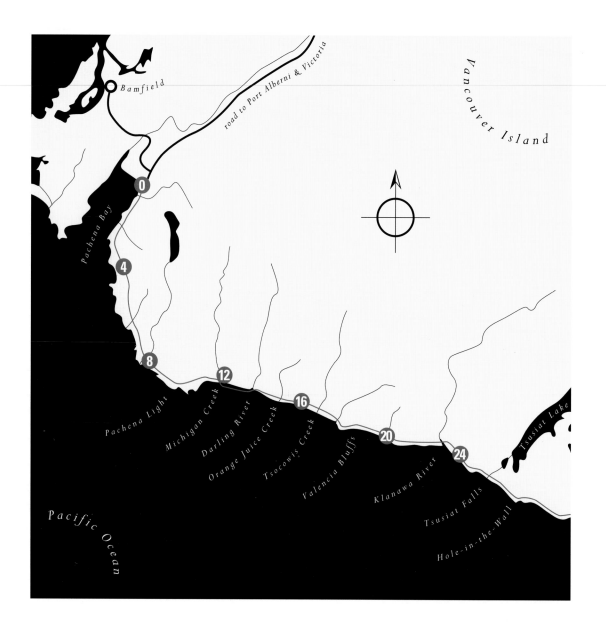

Bamfield

road to Port Alberni & Victoria

Vancouver Island

0

Pachena Bay

4

8

12

Pachena Light

Michigan Creek

Darling River

16

Orange Juice Creek

Tsocowis Creek

Valencia Bluffs

20

Klanawa River

24

Tsusiat Lake

Tsusiat Falls

Hole-in-the-Wall

Pacific Ocean

P A C H E N A T R A I L H E A D

t o

T S U S I A T F A L L S

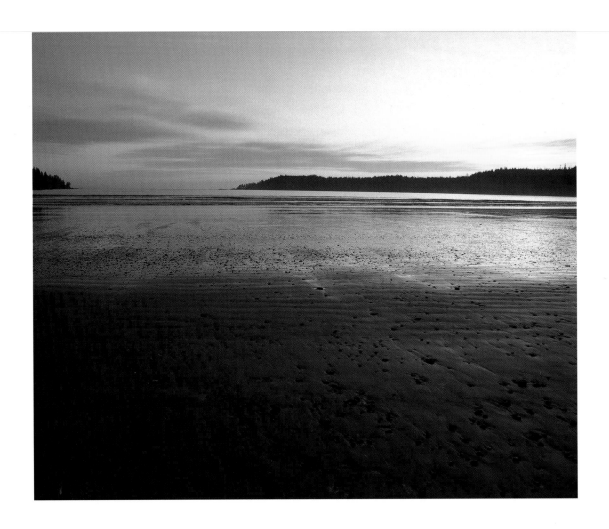

KM.0 — SUNSET AT PACHENA BAY.

Like a spider's web stretched between two branches, countless rough and twisting logging roads link the east and west sides of Vancouver Island, first touching the west coast at Pachena Bay and the western end of the West Coast Trail. The road ends at the village of Bamfield, 4 kilometres further along. Those who have driven the dusty route and whose vehicles have survived the stones along the way can taste their first quiet in hours and sense the changing pace of their journey as they enter the tall stands of cedar and hemlock near the trailhead. Others travel by boat, west down Alberni Inlet on the *Lady Rose*; still others fly into Bamfield by small plane from Victoria or Vancouver, and go from there to Pachena.

The staging area at the trailhead is now only an open field where once stood Camp Ross, a link in the ministry of the Shantyman's Christian Association. A small Parks Canada A-frame cabin is now all that stands watch over the hikers entering and leaving the trail at the west end of the clearing. Many spend their first night on the open sands of Pachena Beach, across the field and through the trees that rim the back of the bay here. By evening, the sand can be dotted with glowing campfires, their tails of smoke curling off into the moist night air and hanging there with the anticipation of the days ahead.

From the trailhead, the path quickly climbs above the east end of Pachena Beach, revealing views back across its broad expanse. Soon however, one loses sight of the water and the waves. The trail winds its way up, over and around the bumps of land and small gullies, above and behind the headlands and steep slopes of the shoreline that the trail skirts as it turns south away from the protection of Pachena Bay. Over these first 10 kilometres the ocean is present only rarely, through its sound and at the few places where side-trails bore

27

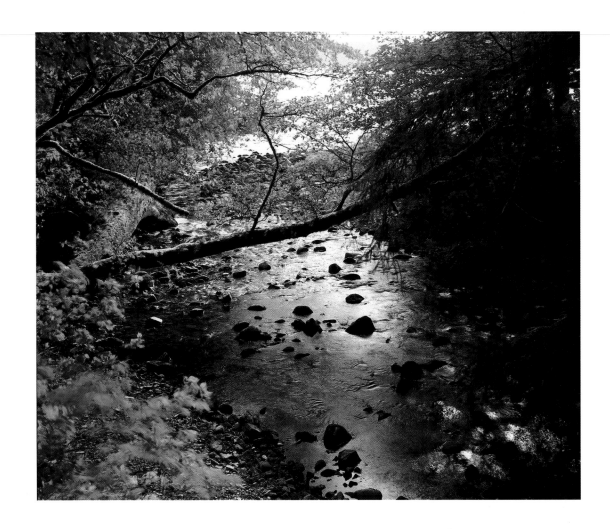

KM.1 — CLONARD CREEK.

through the dense tangle to viewpoints atop cliffs, or drop down steep embankments to isolated beaches.

Within the trail's first kilometre, at Clonard Creek, lie the remains of an early lifesaving cabin. Its broken frame is a reminder of the tenacious and often ill-fated activities of people along this wild coast. Ambitious turn-of-the-century plans to provide road and trail access to the area started here near Bamfield in response to the many shipwrecks occurring along these shores. Although the West Coast Trail had fallen into disrepair before its inclusion in Pacific Rim Park in 1970, its most westerly 10 kilometres was maintained as a wide and well-surfaced access to the Pachena Point Lighthouse into the 1980's. As a result, this first section of the trail is still in good condition despite the visible effects of water erosion and encroaching vegetation.

Evidence of early tree cutting is still visible in the buckboard notches in stumps beside the trail. In the early days of trail construction, not only did trees have to be cut to clear the trail right-of-way, but most materials for the construction of boardwalks, bridges, and other structures had to be extracted from the surrounding forest. Commercial logging was confined to a small area on the slopes of Port San Juan, at the eastern end of the trail. The Clo-ose townsite area was also cleared. Both sites were logged earlier in the century. While not replacing the original forest diversity, these early scars are now fully covered with second-growth trees. Most of the trail structures today are constructed of sawn, treated lumber which is flown onto the trail by helicopter. As well, the lumber being replaced is flown off the trail so as not to litter the surrounding forest.

Hiking east, Pachena Point Lighthouse is the first active man-made landmark on the trail. The neatly clipped lawns, garden plots, and white painted clapboard houses are dominated by the station's historic light

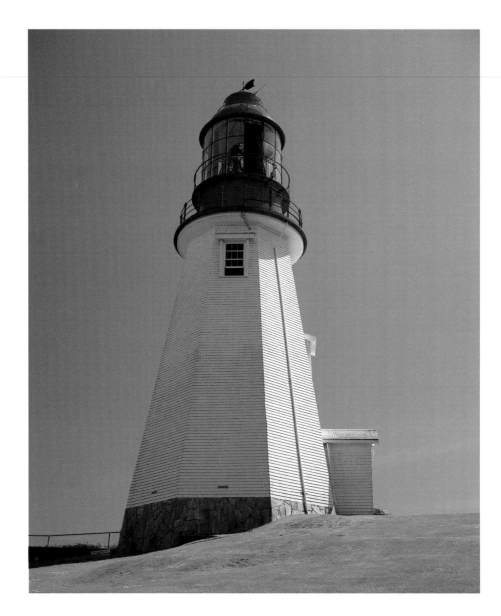

KM.10 — PACHENA POINT LIGHTHOUSE — CONSTRUCTED 1907.

tower. From its lens room, one peers 60 metres down to the sea below, over the undercut face of the point and into the 'gut', a narrow channel from where essential supplies are brought in by boat and 'highlined' up to the station. From up high there are also long views down the coastline. The days of travel ahead fade into the mists to the east. To the beaches below and to the east, Pachena Lighthouse stands as a beacon when the weather closes in, its foghorns triggered by the thickening atmosphere and the pencil beam of its light arcing through fog and the roiling clouds of storms.

From the lighthouse, the trail descends 2 kilometres back to sea level at Michigan Creek. This area of the coastline is edged by a thin sand and stone beach fronted by a wide rock shelf that gently slopes out to the drop-off into deeper water. High on the beach lie the trashed and bleached trees that have been ripped from the forest's fringe during the winter storms of each passing year. At low tide the water retreats 100 metres or so across the shelf, leaving shallow pans of inter-tidal life and the detritus of kelp and other seaweeds torn loose from their moorings. Blue mussels, barnacles, limpets, anemones, urchins, purple, yellow, blood and sun-flower starfish, sculpins, snails, and shore crabs find a home in the pools, crevices and pock-marked surfaces between the high and low water marks. In places the sea penetrates to the sandy beach through cuts in the rock. Pools on the shelf are coloured orange by the tea-stained water flowing from the forest floor behind the beach. On a warm day the shelf sweats as thick vapours rise from all this life in the rock. Listening carefully, one may hear the background static of drying organic matter, the trickle of small rivulets searching out the sea to the last drop, or the shuffling legs of small creatures.

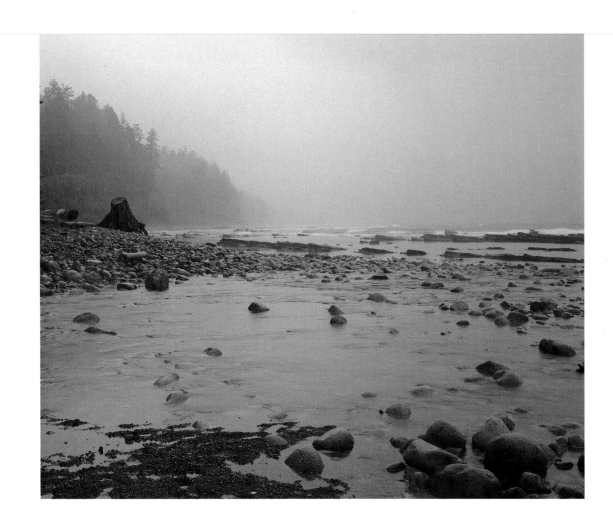

KM.12 — THE MOUTH OF MICHIGAN CREEK.

Twice each day the water rises and recedes with the tide, cleaning the plate, bringing in new, cold water and food for the life that clings to the rock. The tides also wash ashore flotsam that may have drifted across an entire ocean. We travel as observers to a living, changing process as it weaves us through this strand of rock and sand where the land enters the sea. One is reminded of T.S. Eliot's lines from *'The Day Salvages'* in *Four Quartets*:

> *The river is within us, the sea is all about us;*
>
> *The sea is the land's edge also, the granite*
>
> *Into which it reaches, the beaches where it tosses*
>
> *Its hints of earlier and other creation:*

Michigan Creek is the first of many streams and rivers that cut down to the ocean along here. This stream is named after the wreck of the coastal steamer Michigan which foundered on these rocks in 1893. As one of the few clear remnants of the trail's tumultuous past, the boiler of the Michigan remains wedged in rock at the mouth of the creek that bears its name. Names of other streams reflect both an aboriginal and a European past: Darling, Orange Juice, Tsocowis, Klanawa, Tsusiat, Cheewhat, Carmanah, Walbran, Logan, Cullite.

The Darling River flows from its valley less than an hour's walk east of Michigan Creek. At one time, the creek was spanned by a usable hand-propelled cable car, a guarantee of passage even at high water. Several creeks and rivers along the route are likewise equipped — small marvels of 'bush' engineering.

FALLS AT ORANGE JUICE CREEK.

At Tsocowis Creek the path climbs off the beach to skirt the impassable headlands beyond. The creek flows through a deep, scoured bowl in the cliffs above before plunging over a fall, onto the beach and out to sea. The trail climbs high here to cross the gorge by a suspension bridge. From this vantage point, the smooth backs and wispy spumes of migrating Grey whales can often be seen. Beyond Tsocowis, the trail passes a point above the site of the Valencia wreck, that wrenching event embedded in the trail's past.

A few kilometres later, the trail returns to the beach and eventually reaches the Klanawa River. During the summer, great flocks of migrating gulls may gather here on the beach. Above, from high in their aeries, bald eagles survey the shoreline. Elsewhere, ravens, mergansers, scoters, oystercatchers, hummingbirds, and kingfishers find homes in the forests and waterways along the shore. Beyond the Klanawa, the trail climbs into the forest once again. Over headlands, the route runs close to the edge of rock faces that drop into deep surges or small, unreachable pockets of beach. On the approach to Tsusiat Falls there are tantalizing glimpses of the beach ahead; fragments of azure seen through the black knots of branches, before the trail emerges at the top of a cliff, mere metres from the brink of the falls, before turning to cross at the river's bridge upstream.

Unchangeable save to thy wild waves' play;

Time writes no wrinkle on thy azure brow;

Such as creation's dawn beheld, thou rollest now.

— *Byron*

KM.5 — SKUNK CABBAGE.

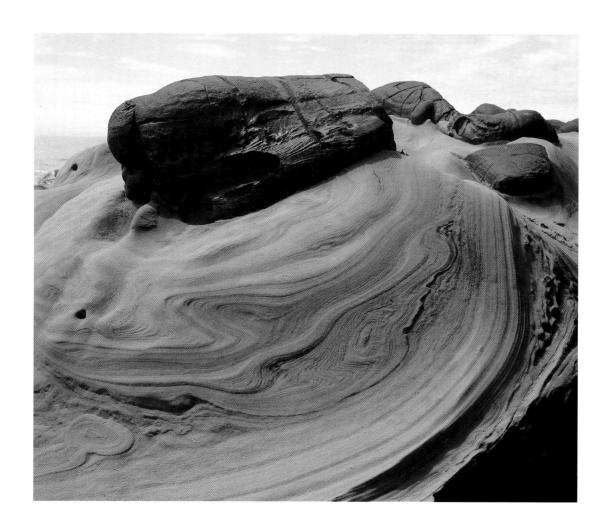

KM.7 — ROCK FORMATIONS.

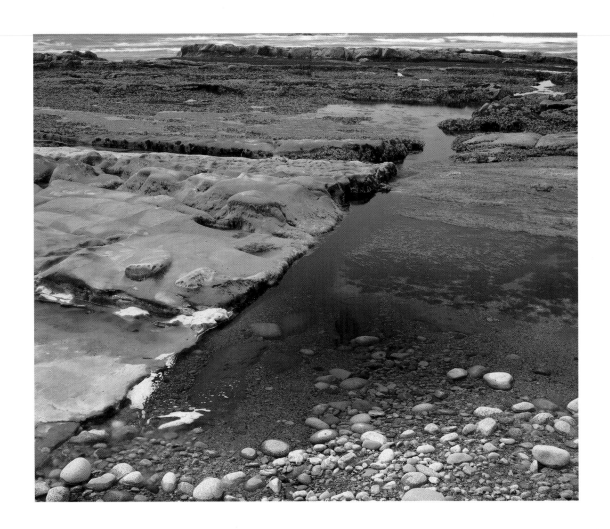

KM.13 — ORGANICALLY RICH WATER FLOWING ONTO THE SHELF BETWEEN MICHIGAN CREEK AND THE DARLING RIVER.

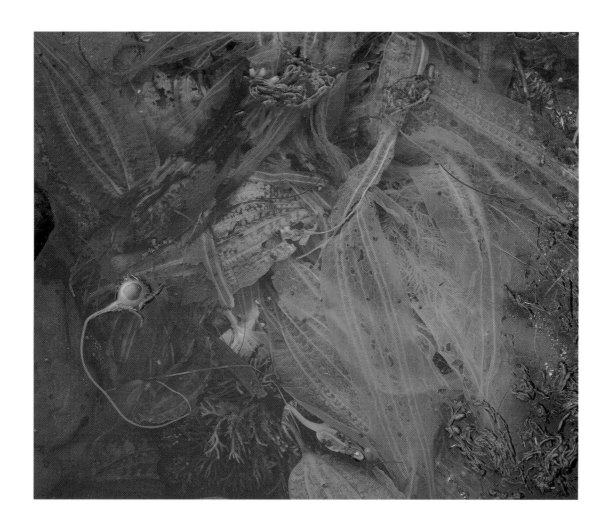

KM.13 — SEAWEEDS IN A TIDE POOL.

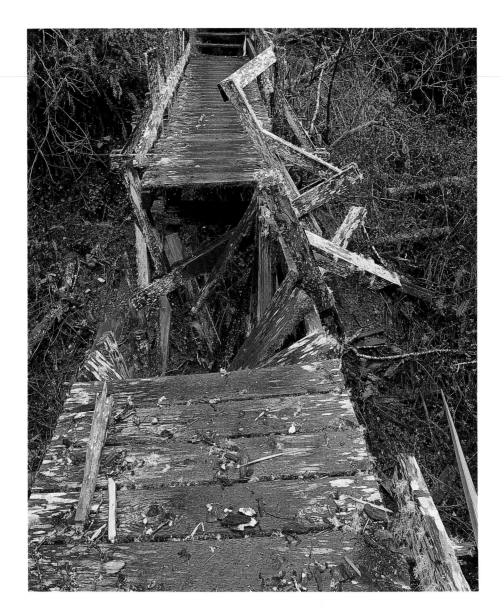

KM.0 — WINTER DAMAGE NEAR THE PACHENA TRAILHEAD.

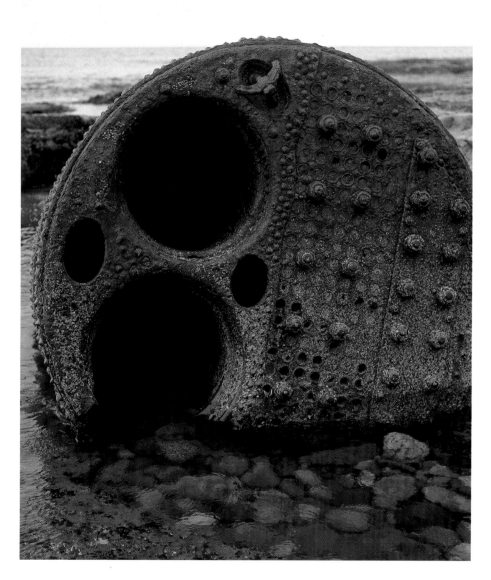

KM.12 — THE BOILER FROM THE 1893 WRECK OF THE 'MICHIGAN', NOW LODGED AT MICHIGAN CREEK.

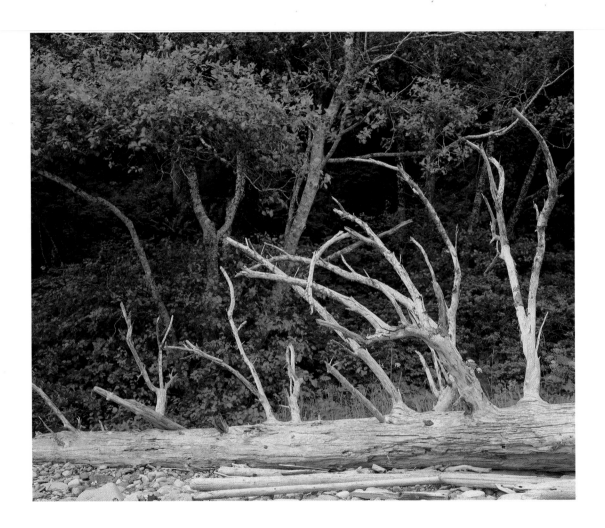

KM.15 — DRIFTWOOD.

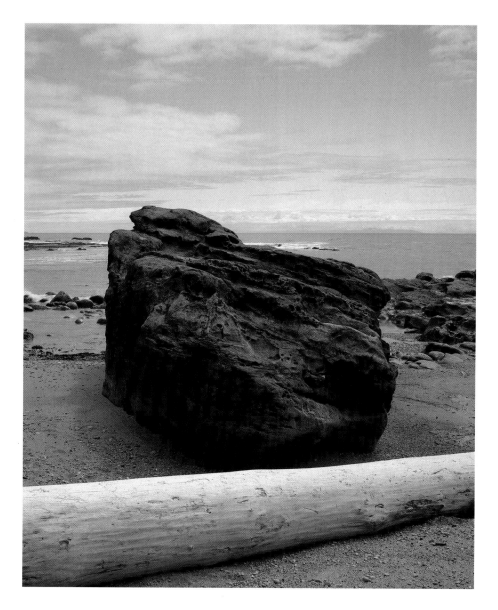

KM.16 — BEACH NEAR TSOCOWIS CREEK.

Vancouver Island

Nitinat Lake

Tsusiat Lake

Cheewhat Lake

24

28

Tsusiat Falls

Tsusiat Point

Tsuquadra Point

32

Tsuquanah Point

Nitinat Narrows

Whyak

Clo-ose

36

Clo-ose Bay

Dare Point

40

The Cribs

Dare Beach

44

Carmanah Point

Carmanah Beach

48

Bonilla Point

Vancouver Point

Pacific Ocean

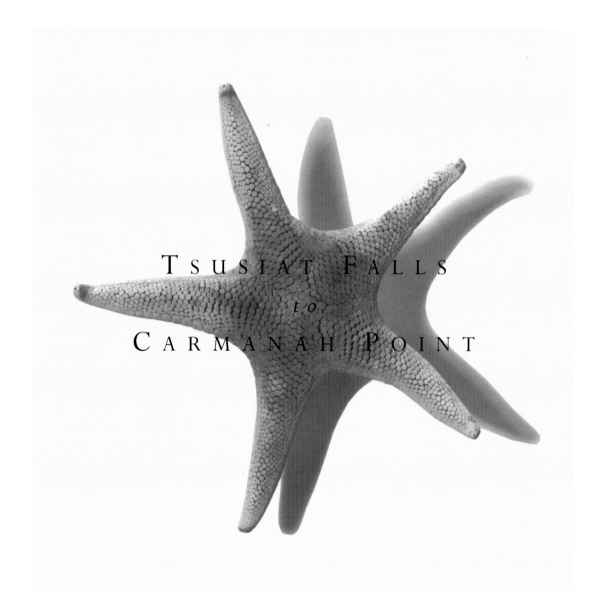

T S U S I A T F A L L S

to

C A R M A N A H P O I N T

KM.25 — TSUSIAT FALLS.

At low water the flow of the Tsusiat River runs as a thin sheet across its sandstone bed, pausing and swirling through potholes in the rock, riffling past steps and overhanging branches before dropping over the lip of Tsusiat Falls. From the bridge over the river, looking seaward to the brink of the falls a few metres away, one can see, at times, an imperceptible, seamless transition from water to the sky beyond. For a moment the falls cease to exist and one's view is flattened into a tranquil scene of imaginary space.

Just beyond the bridge a steep ladder descent leads to the beach near the base of the falls. Despite its popularity, the falls remain one of the trail's magic places. Even at low water it casts its veil across a wide, stepped rock face, sending up cool mists and rainbows before plunging to the pool below. The endless falling sheets and sprays of water have become a trail icon. This focal point on the coastal journey is a favourite bathing spot, a stopover spot, and a scene at which to marvel.

Winter storms and tides mould and shift the beach here and elsewhere. The falls' plunge pool sits dammed behind the steep berm of the beach, its contained water probing through the sand and gravel for an easy contour to the sea. From year to year the outflow from the falls finds fresh channels to the ocean, changing the face of the beach in the process.

The Tsusiat River flows over the high cliffs that start just east of the Klanawa. East of the falls, the bluffs turn inland and the next beach along widens and stretches out for a kilometre. At the end of its sweep, the sand narrows and turns around another abutment, onto a smaller beach, past pockets of sand and logs between toes of rock, before threading the 'Hole-in-the-Wall' at Tsusiat Point. Through the aperture of this

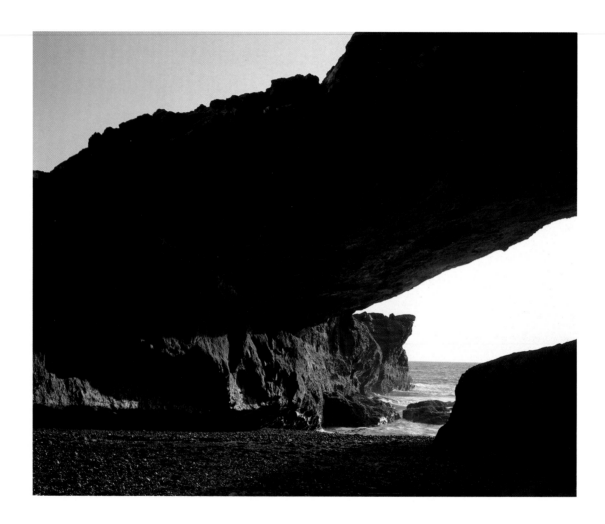

48

KM.27 — 'HOLE-IN-THE-WALL' AT TSUSIAT POINT.

natural rock bridge one can look east toward the tucked entrance of Nitinat Narrows, some 5 kilometres away. Behind, Tsusiat Falls lies hidden by now, yet continues to linger in one's memory.

Countless small, scalloped beaches lie beyond the point, their stones and sand mix, spread and shift into patches of hardpack, pockets of soft, sugary sand, and ridges of stacked marbles. Such conditions can make walking hell at times; one's striding energy is absorbed by soft sand or by stones that turn and roll under one's boots. Despite the directness of beach routes, variable sand conditions and the slope of the beach face can take a toll on joints and muscles.

Approaching Tsuquadra Point, the trail winds over and around headlands, and between the open beach and forest glades. These are higher, rockier, more open bluffs. Dramatic shorepine, spruce and sculptured salal enliven the clifftops. The trail skirts the creviced coastline past Tsuquanah Point, then turns inland, finally dropping to the waters of Nitinat Narrows.

Nitinat Narrows is the trail's psychological turning point. Those walking east have warmed to the trail; those headed west are satisfied that they have won the test of the trail's most difficult sections. The 2 kilometre long Narrows is the throat through which the tidal Nitinat Lake both gathers and empties its contents. Every six hours the sea streams and gurgles through the shallow waist of the channel, swirling into eddies and sweeping all water-borne matter before it. A fifteen minute 'blink' is the only respite between tides. Boats have foundered on the sandbar at the Narrows' entrance. Oblivious to the danger, a few lucky people have swum the hundred metre gap where the trail is cut by the turbulent waters.

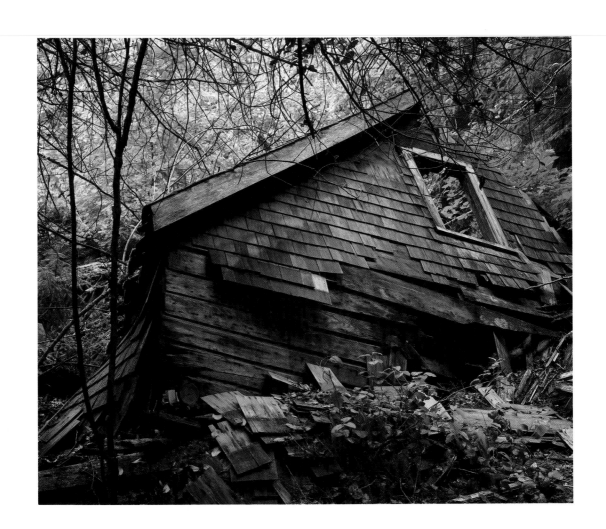

KM. 34 — REMAINS OF A HOME ON THE BLUFFS WEST OF CLO-OSE.

Carl's ferry drops hikers at a small dock on the east side of the Narrows. From here out to the mouth of the Narrows is Indian land, within which lies the seasonal outpost of Whyac. The trail passes across the east side of the reserve for a kilometre through forest before reaching the clifftops overlooking the shelf that runs between Whyac and Clo-ose. Much of the boardwalk through here has been replaced, though it still requires constant maintenance. These split-cedar and planked wooden sidewalks keep people from churning up the forest floor, but while they span roots and rocks, they present their own challenges.

During dry weather, boardwalk travel can be fast and efficient. Walking is emboldened by a stable surface and one's strides lengthen. With the damp and the wet, though, come the trail's special hazards. Good balance becomes essential. Boards become as slick as wet, polished ice. Collapsed, tipped, sloped or undulating sections of boardwalk can send a body crashing down. A slip with a heavy pack can splay legs, tear muscles and tendons and fracture bones. The wet surface shortens one's stride and demands greater care. The lugs on one's boots search out the nubs of nailheads, raised knots and the level spots on the edge of boards. It is one of the trail's small ironies that structures that have been put in place to help travel should also present one of its greatest dangers. This is a foretaste of conditions east of Walbran Creek, two days from here. The trail becomes earthen again as it runs along the top of the cliffs and around high headlands down into Clo-ose.

Like Whyac, Clo-ose lies on Indian land. Once the sight of permanent occupation, it is now only used seasonally. The homes of its former residents have been abandoned to the shooting tangles of salmonberry

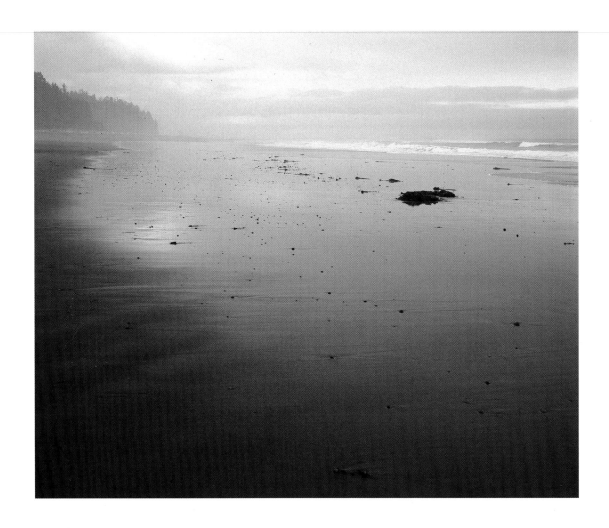

KM.36 — 'LONG BEACH' IN CLO-OSE BAY.

and dense salal that, each year, also choke the trail through here. As with other abandoned coastal settlements, the domestic plants introduced to bring civility to gardens and stand as nostalgic reminders of 'home', have spread to the surrounding clearings without the restraining hand of former residents. Travellers through the area encounter plants as out of place as foxglove, day lily, hydrangea and poppies. Even a broad-leaved maple stands outside the old post office.

Past Clo-ose the path passes by the small tidal estuary of the Cheewhat River, and onwards to a suspension bridge 200 metres further upstream. Along the tidal flats one may be lucky enough to see the tracks of marten, mink, river otters, racoons, beaver, black bear, cougar or black-tailed deer.

Off the end of the Cheewhat suspension bridge and through a half-kilometre of wide, groomed trail, one arrives back at the open beach of Clo-ose Bay. Traces of settlement linger here too. The land between the river and the beach, once cleared as part of the Clo-ose townsite, is now marked by second growth forest. The trail through the trees and behind the beach continues to be cleared back to its early road-like dimensions. Old man-made clearings behind the beach fringe have also resulted in a sand blowout, or dune area, partway along the beach. Like the old forgotten name of this stretch of sand — *Long Beach* — vestiges of the old community have been lost in time.

Back on the beach conditions remain much as they have always been. Fine sand that stretches for a kilometre along the shore extends a flat 100 metres out to the sea's edge at low tide. Late at night, by a fire at the top of the beach, a cool sea breeze at one's back, radiant heat warming one's face and shins, and stars

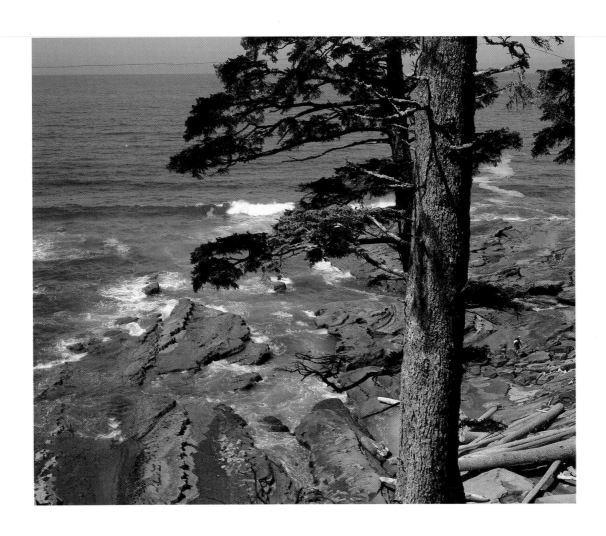

KM. 38 — TIDE RISING ON THE SHELF NEAR DARE POINT.

overhead undimmed by city lights, it is easy to understand what once drew people here and just as easy to forget that people have ever been here.

Each man who watches the sea, the fire,

the seasons, who wonders that he is alive

and that he must die, is, in fact, everyman.

— *Claude-Henri Rocquet*

At the eastern end of the beach, Dare Point, the hardpacked sand becomes hard rock. Between here and Dare Beach, 4 kilometres to the east, lies the first earnest section of inter-tidal sandstone shelf for those walking from the west. As with many sections along the trail, there is the option of travelling the path back in the trees, safe from the reaches of high water and protected from the wind. Normally, the shelf is a faster and more direct place to travel. However, weaving a route that is less direct than the path above, the shelf here offers the slower alternative. The shelves are lively places, not only for their pools of marine life but for their slick and coarse surfaces, their breaks and surges, and their blocks and chunks of rock. Along certain stretches, the shelf lies as a flat table of sandstone skimmed with sheets of water, divided and held only by the beads of interlaced intrusions that have withstood the endless erosion. The forest is an intimate place, subject to growth and decay; the beach and the shelf are more expansive and

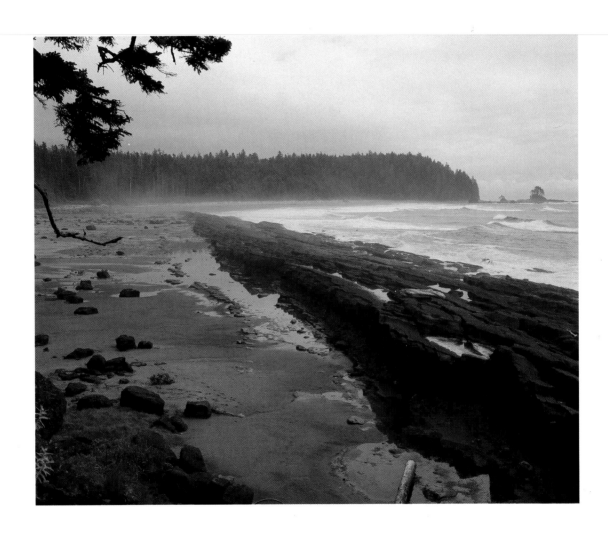

KM.41 — 'THE CRIBS' AT DARE BEACH.

exposed to the incessant cut and thrust of earthly elements, of the wind, the sand, the sea and the salt spray.

The sea and the wind gnaw at the cliff faces that drop to the shelf below. On top, the cliff fringe is knit with krumholtz and salal. In places, the trail burrows through this dense plant warren, oblivious to the exposure metres away. Elsewhere, the trail tempts the very lip of the precipice. Colluvial sediments creep over the bedrock under the pull of gravity, pushing towering trees to the cliff's edge. Eventually, the trees' foundations are undercut, and they topple to the rocks below. With their roots come tons of earth and till. Over time, the fractured trunks and shattered limbs will be stripped and smoothed by countless tides, and scattered along the coastline to join the wrecks of other trees.

The trail's split routes join again briefly at the *Cribs*, a series of mammoth tipped slabs of conglomerate that shield the top end of Dare Beach (once also known as *Whispering Sands* beach). From the Cribs, Dare Beach stretches for more than a kilometre toward the headlands of Carmanah Point and the trail's other lighthouse. The path leads past Cribs Creek, Coal Creek, and the skeletons of ten thousand trees living an afterlife as stacked and contorted sculpture high up on the beach's smooth sands.

The trail through the forest crosses Carmanah Point behind the light station and descends by ladder to the end of Carmanah Beach. On reef rocks just off Carmanah Point, an impressive colony of sea lions congregate. Although easiest to see from atop Carmanah Point, they can more often be identified by their sound, like that of a pack of baying hounds. Grey whales also frequent the waters off Carmanah at different times of the year, sometimes passing within metres of the shore during their coastal meanderings.

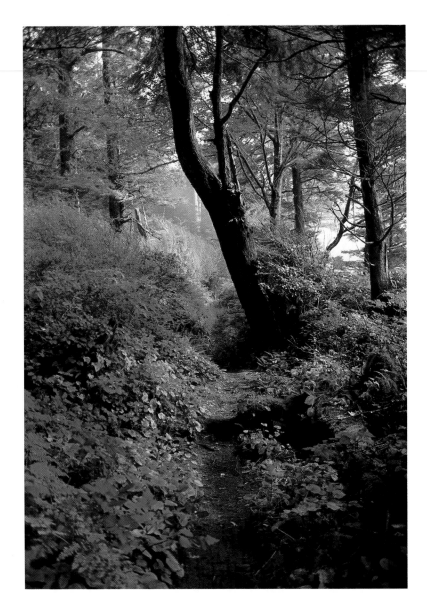

KM.34 — CLIFFTOP TRAIL WEST OF CLO-OSE.

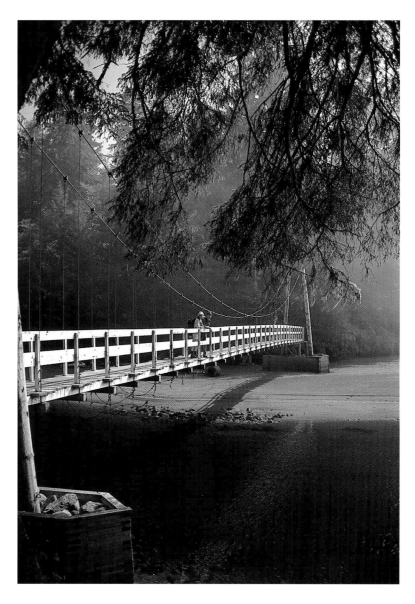

KM. 36 — CHEEWHAT RIVER SUSPENSION BRIDGE.

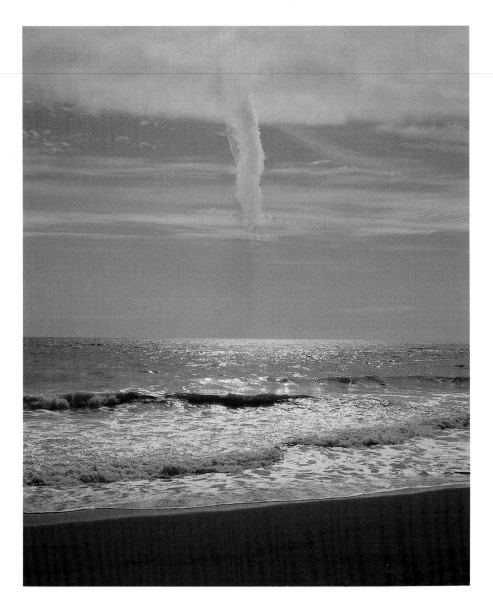

KM.37 — CONTRAIL OVER CLO-OSE BAY.

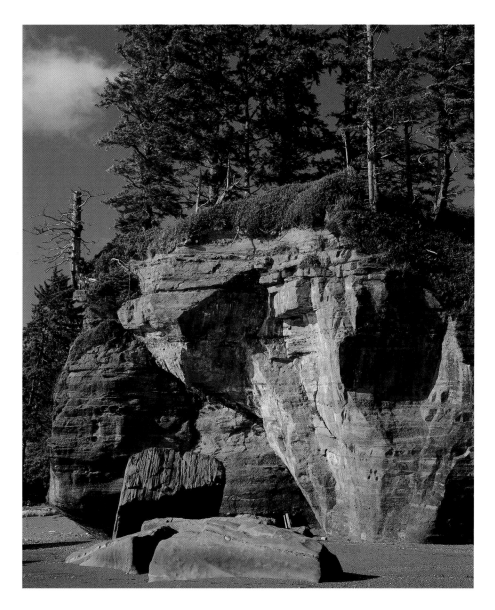

KM.27 — HEADLAND NEAR TSUSIAT POINT

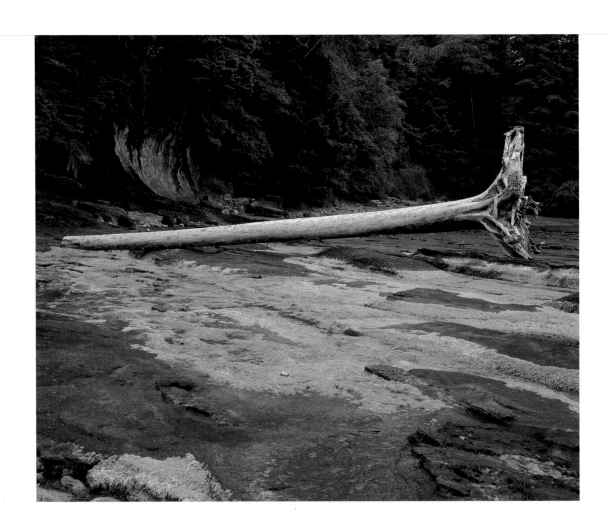

KM.37 — STRANDED LOG AT DARE POINT.

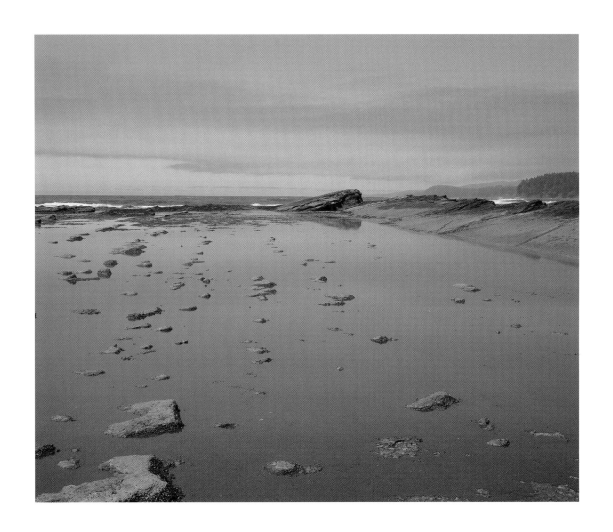

KM.38 — SANDSTONE SHELF AT DARE POINT STARTING TO FLOOD WITH THE RISING TIDE.

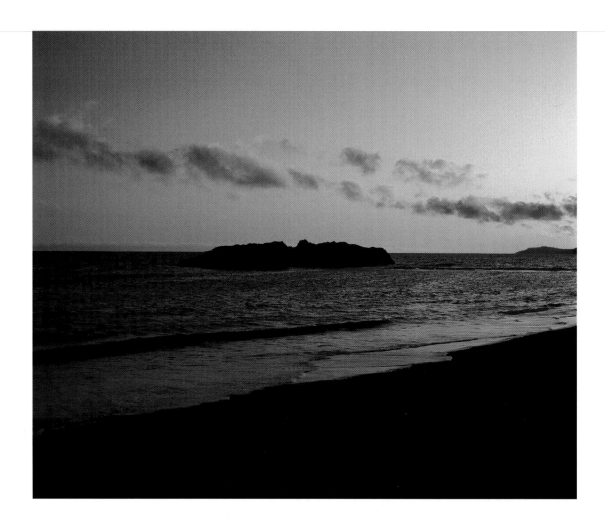

KM.27 — SUNSET NEAR TSUSIAT POINT.

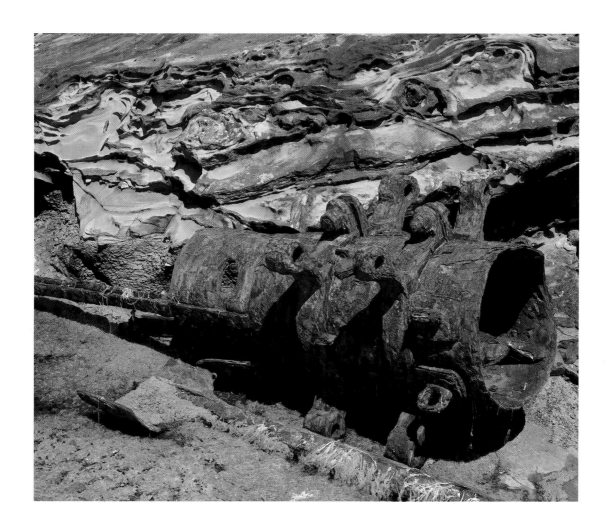

KM.39 — REMAINS OF THE 1923 WRECK OF THE 'SANTA RITA'.

KM.36 — 'LONG BEACH', CLO-OSE BAY.

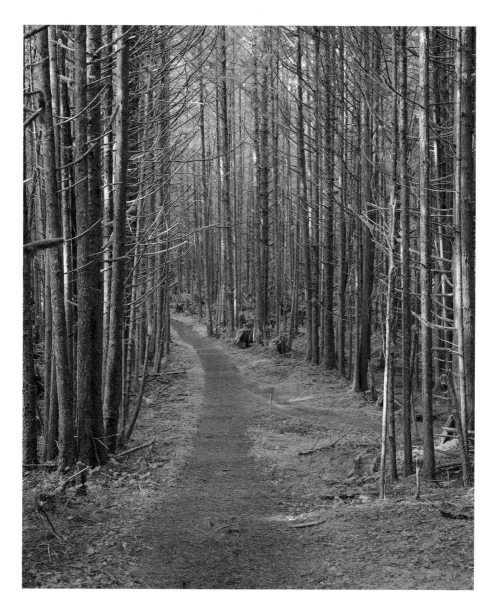

KM.36 — TRAIL THROUGH SECOND GROWTH TREES AT THE OLD CLO-OSE TOWNSITE.

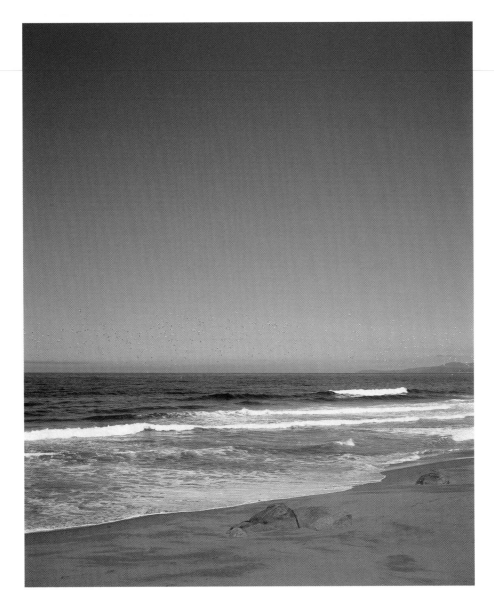

68

KM.42 — DARE BEACH.

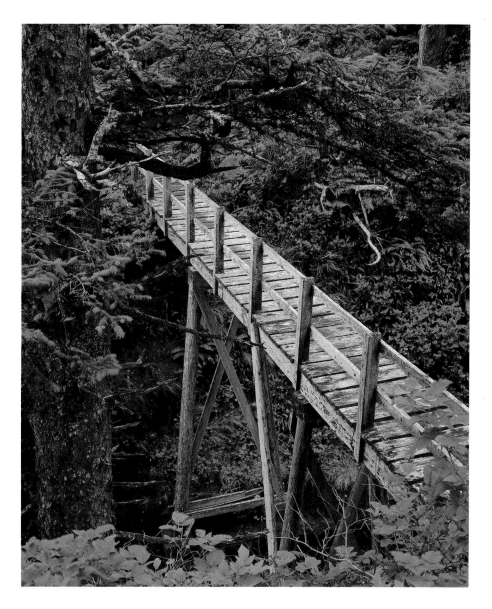

KM.40 — BRIDGE EAST OF DARE POINT.

KM. 31 — WINDSWEPT TREES AT TSUQUANAH POINT.

KM.40 — TIDE POOL REFLECTIONS.

Vancouver Island

Carmanah Point

48

52

56

Bonilla Point

Vancouver Point

Walbran Creek

Adrenaline Surge

Logan Creek

Cullite Cove

Sandstone Creek

60

Camper Bay

Trisle Creek

64

Owen Point

Kellett Rock

68

Thrasher Cove

highest point on trail

Gordon River

75

72

PORT SAN JUAN

Port Renfrew

Botanical Beach

Pacific Ocean

CARMANAH POINT

to

PORT SAN JUAN

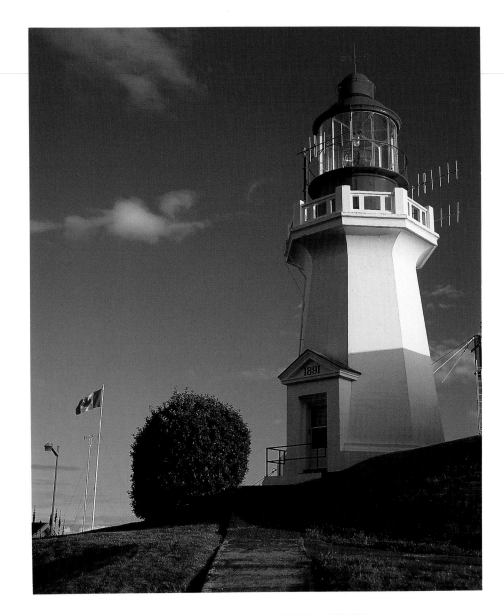

74

KM.44 — CARMANAH POINT LIGHTHOUSE — BUILT 1890.

B elow the lighthouse spreads the glorious crescent of Carmanah Beach, bisected by the outflow of Carmanah Creek and beyond, inland, the Carmanah Valley. The watershed, now a park, provides an environment ideally suited to giant trees. Within its old growth forest are trees with names like The Three Sisters, Heaven Tree, Coast Tower, and the 95 metre tall, 400 year old Carmanah Giant, the tallest tree recorded in Canada and thought to be the tallest Sitka spruce in the world. Other trees have survived in the valley for over one thousand years. Throughout its upper reaches and down to the beach, Carmanah Creek carries with it a strong sense of an ancient past that evokes reverence in those that cross its waters.

All streams run to the sea,

but the sea is not full;

to the place where the streams flow,

there they flow again.

—— Ecclesiastes

The east end of the beach becomes rocky once again, then turns a corner into the sea stacks of Bonilla Point. These rocky artifacts of a surrounding coastline, long since eroded, are often tree-topped and fringed with wind-swept grasses like enormous anemones tipped in the wind. Others conjure up the

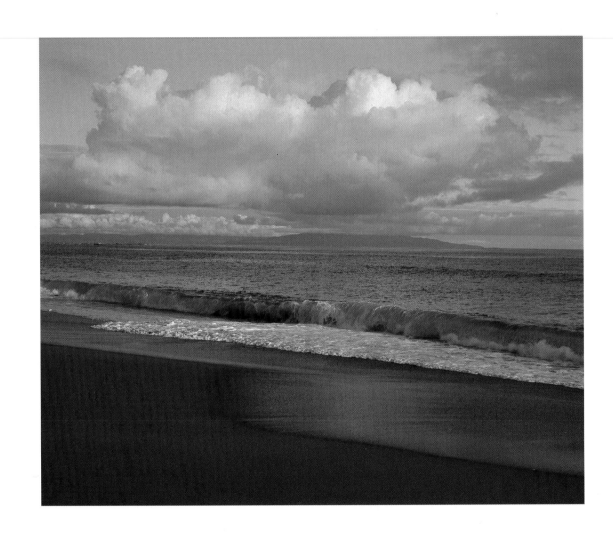

KM.45 — CARMANAH BEACH LOOKING SOUTH, ACROSS THE STRAITS OF JUAN DE FUCA, TOWARD CAPE FLATTERY.

sterns of ships sinking beneath surf or the fingertips of some giant hand now frozen in a once molten sea, edges and surfaces scoured and bitten by wind and surf over the many lives of ancient trees.

At Bonilla Creek lies evidence of yet another wrecked hull. Sections of its heavy timbers and planking have been pushed high up on the beach where they have dammed a small pool at the foot of the delicate cascade where Bonilla Creek drops over a rock ledge. Trees now grow from the implanted ship's timbers, all but obscuring this tiny sanctuary from those casually passing at the foot of the beach.

The beach route continues past Kulaht Creek and Vancouver Point, before reaching Walbran Creek, the first and largest of the four major drainages on the bottom section of the trail. Just inland from its mouth the river is wide and boulder-strewn. Below this broad rock garden, the river's water collects in a deep pool from which it flows in a channel through shifting gravel to the sea. Overlooking the large pool rises a tall, rocky promontory, its face carved into an amphitheatre. Above the boulder garden a long cable car crosses the river, though most people wade at its mouth during the low tide.

The outstanding feature of the eastern end of the trail, between Walbran Creek and Owen Point, is the nearly continuous sandstone cliff and abutting shelf formation. Averaging 25 metres high, in places the cliff face reaches over 50 metres. The trail's geology results from a 200 million year history of volcanic action, glaciation and sedimentation. Depressed and fed by glacial ice, the Carmanah formation underlying the trail area was a narrow, submerged, coastal strip along which sedimentary deposits collected. These conglomerates, mudstones and sandstones overlay the pre-Tertiary dioritic

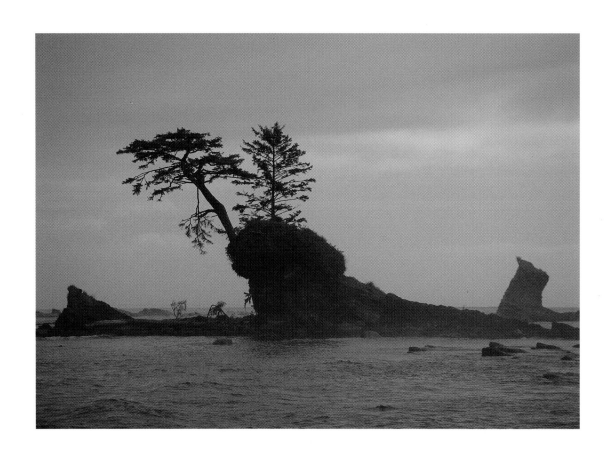

78

KM.48 — SEA STACKS AT BONILLA POINT.

and shistose rock of the area. While glacially depressed, the surf eroded the shoreline rock below the high tide mark, leading to the formation of the cliff features found along the trail today. Uplift of the land after the glaciers receded revealed the modern coastline which continues to be shaped into beaches, headlands, arches, caves and sea stacks by the forces of erosion.

On the shelf route between Walbran and Logan Creek several surge channels must be crossed, notably at Adrenaline Creek. Aptly named, this small creek flows in a sheet over the cliff face and into the deep cut of Adrenaline surge channel. Surges are one of the risky challenges to be faced by shelf walkers. Ocean swells rise up against the outer edge of the shelf, sweeping up into these breaks in the rock. Where surges have eroded to the base of the shoreline cliffs, passage may only be possible through the head of the channel at low tide. These are inter-tidal zones. When wet, rock surfaces can be treacherously slippery. Adrenaline surge, with its narrow window of tidal opportunity, steep walls, slick boulders, and waterfall demands respect from those that travel this way. Under ideal conditions, this is the easy way along this part of the coast, yet people have died here attempting the crossing. Those feeling prudent travel the forest route.

The climb out of Walbran Creek is the first contact with the long ladder ascents and descents in and out of the creek gorges ahead. The ladders climb through a series of stations, small platforms, rising in some cases over two hundred rungs before the forest flattens out above. Once on top, the trail meanders through moist forest and at times through open bog, its saturated ground only able to support

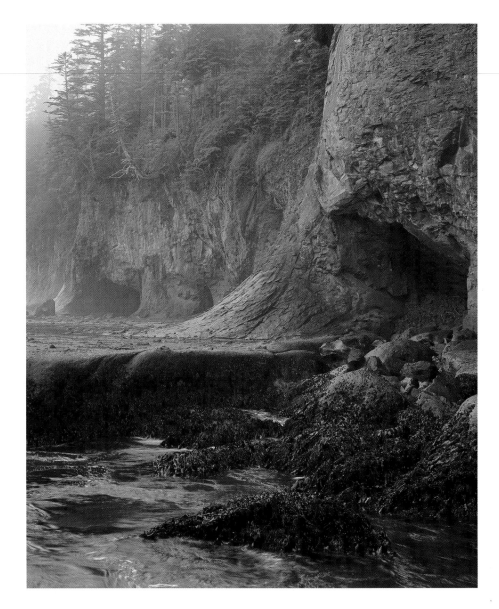

KM.55 — THE COASTAL SHELF NEAR ADRENALINE SURGE.

bunchberry, stunted shorepine, red cedar, a spongy carpet of sphagnum moss, and other plants adapted to these specialized conditions. Many sensitive areas have been boardwalked, particularly through bog and swamp. Not only does the uniquely adapted flora need protection from careless footsteps, but a misstep can land one thigh-deep in mud. Elsewhere, the trail follows winding paths up and over roots, around and through mudholes, through gullies and over moss-slicked logs.

The trail from Walbran eventually leads to the lip of Logan Creek. From high above the stream, another series of ladders descends precipitously to a point halfway down the west face of the gorge, where they meet the end of the Logan suspension bridge. Perhaps the trail's most spectacular feat of engineering, the bridge is bolted into the walls of this small canyon, some 20 metres above the creek bed below. A single plank suspended between twin cables spans the 100 metres between sidewalls.

The mouth of Logan creek is flat and expansive, the coastal shelf broadening and wrapping into its bay; Cullite Cove on the other hand is tight and enclosed, its guardian headlands pinching in at the mouth. Its steep beach is formed of rounded, eroded and tumbled rocks, and its east side shaded by the face of a high cliff. Like other small streams at low water, the creek does not always flow in a channel to the sea. Instead, it pools behind the crest of the beach, its flow drained underground in spaces between the stones that compose the beach's coarse crescent. The level of the holding pond is held static by a balance between the inflow of water from above and the seepage of water below. The cove is not visible from the trail. It requires a diversion, though one worthwhile for the unique dimensions of this place.

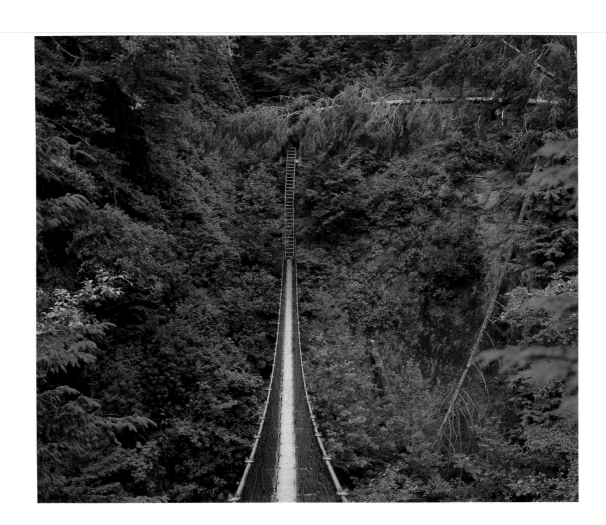

82

KM.56 — LOGAN CREEK SUSPENSION BRIDGE.

With the long ladder climbs and shelf diversions at the eastern end of the trail, come long serpentine stretches through the closed space of the rainforest. Biomass accumulates in the heavy rains and mild climate. From the trunks of fallen trees springs other life. New trees grow, rooted in the rotting hearts of these 'nurse' logs. While open below its canopy, the forest floor can be dense with ferns, moss, skunk cabbage and the decaying substance of dead trees. Left to its own processes, the ground becomes indeterminate, layer upon layer of interlaced matter collecting into a lush layer of greens and browns. The air, too, is thicker in the woods; sounds seem closer and the sun sets earlier. Views are filtered and sightlines are short. It is a realm quite distinct from the shore.

Once on the trail, a natural rhythm evolves in response to walking conditions and the weather, the spacing of creeks and the cycles of the tides. Some people will travel ten kilometres in a day, some five, others twenty. At Camper Bay these human waves join and amplify, as those spending their last night on the trail join camp with those here for their first night. Experience mixes with excitement. Visions of burgers and beer co-mingle with menus of dried this and dehydrated that.

Like the other watercourses on the lower end of the trail, Camper Creek has cut out a steep-sided valley and flows out through cliffs and a gravelled beach to the sea. Like the others, it is also unique for its shape and scale. The potholes eroded into the nearby tidal shelf, the depth of its pools, the seasonal arrangements of logs on the beach, and the sweep of its gravel bar compose its unique character.

A final high ascent out of this last valley brings one back to the intertwined routes of the trail. Within

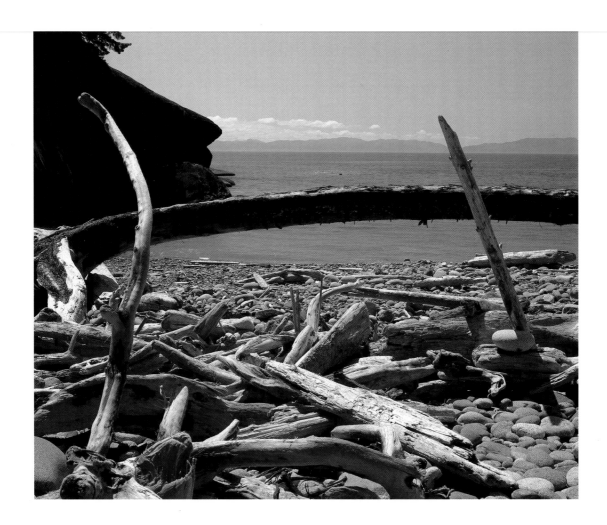

KM.58 — CULLITE COVE.

a few kilometres several access paths lead from the forest down to the shelf. At low tide quick progress can be made to Owen Point where the route turns east into Port San Juan and the village of Port Renfrew. At Owen Point the scoured caves and overhangs evoke the sculptures of Henry Moore and of bones inflated to a grand scale. In places bright green moss patines the rock. Trees close in from above and modulate the light.

From here, the end of the trail is in sight. Along the shoreline of Port San Juan from Owen Point, the route passes Kellett Rock, tucks into a few tight beaches and passes through dense fields of boulders and around 'house' rocks, until finally it reaches Thrasher Cove. For some, the trail begins and ends here. By boat, one can get to Port Renfrew across the bay. The trail through the forest continues another 5 kilometres, over its highest point of 200 metres, to the Gordon River at the head of the bay. This is the end of the journey for those walking from Bamfield — and the beginning of the journey for those walking west from Port Renfrew. The days of walking begin and end, but the journey's echoes will linger in the memory of all those who have travelled this coastline.

Vext the dim sea: I am become a name;

For always roaming with a hungry heart

Much have I seen and known …

 — *Tennyson, from 'Ulysses'.*

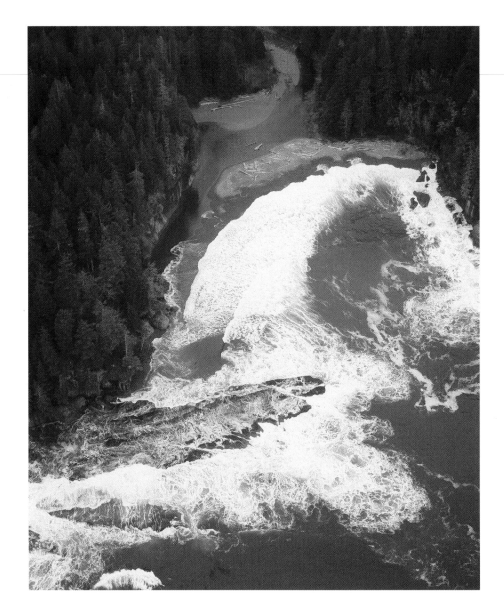

KM.62 — CAMPER BAY AT HIGH TIDE.

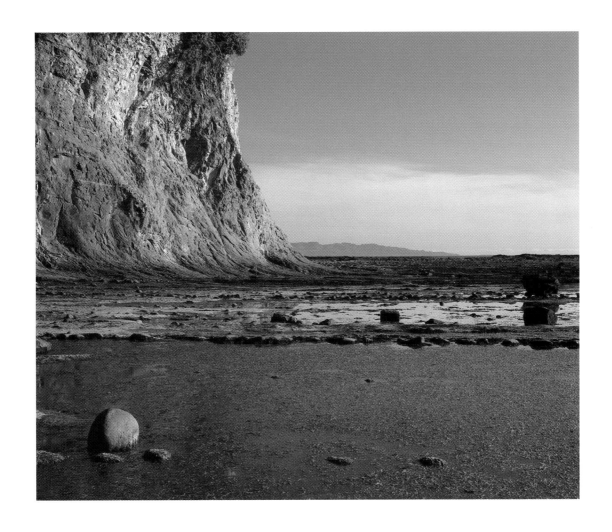

KM.56 — SANDSTONE SHELF AT LOGAN CREEK.

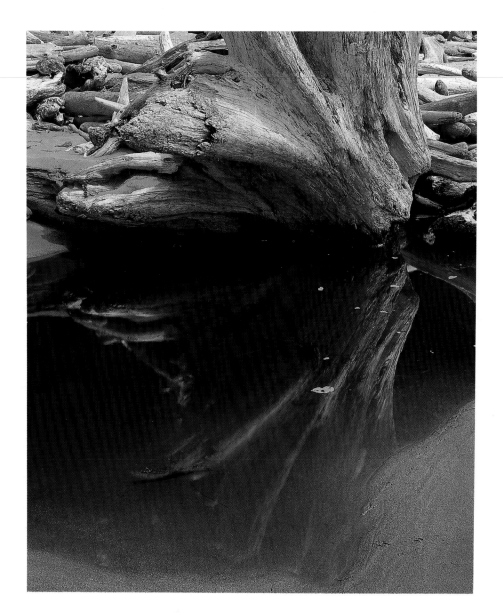

KM.45 — LOGS ON CARMANAH BEACH.

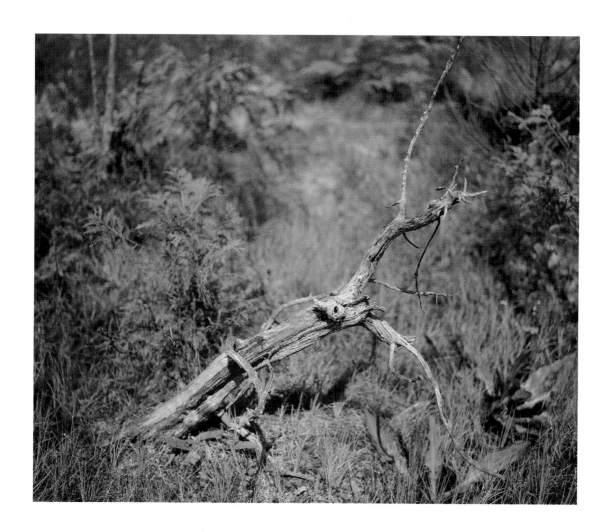

KM.54 — BOG AREA.

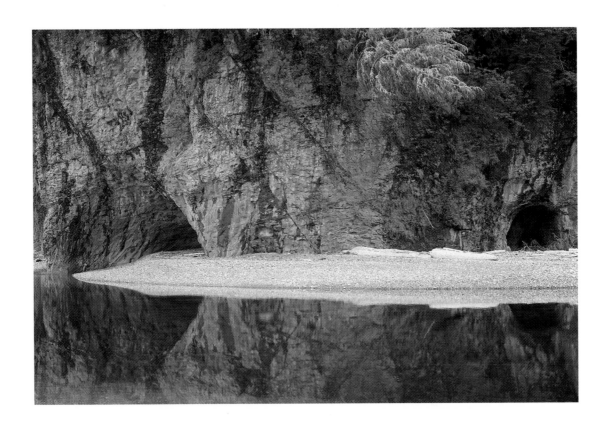

KM.53 — POOL AT THE MOUTH OF WALBRAN CREEK.

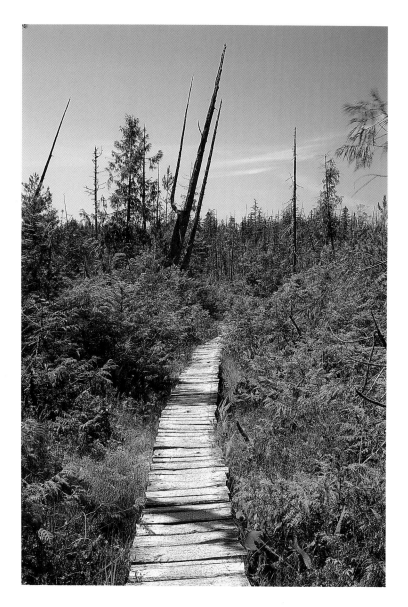

KM.54 — BOARDWALK THROUGH A BOG AREA.

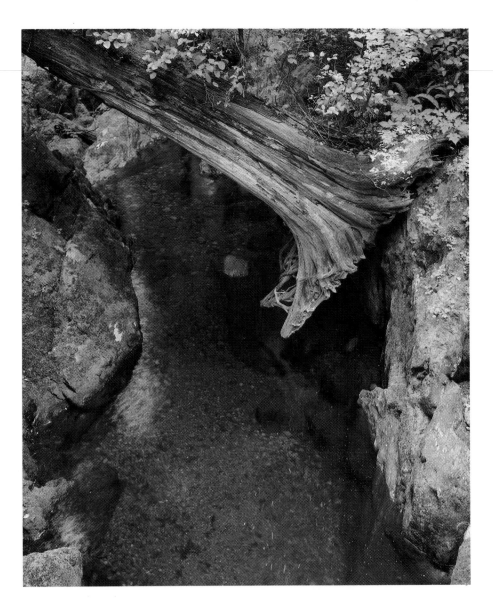

KM.63 — TRISLE CREEK.

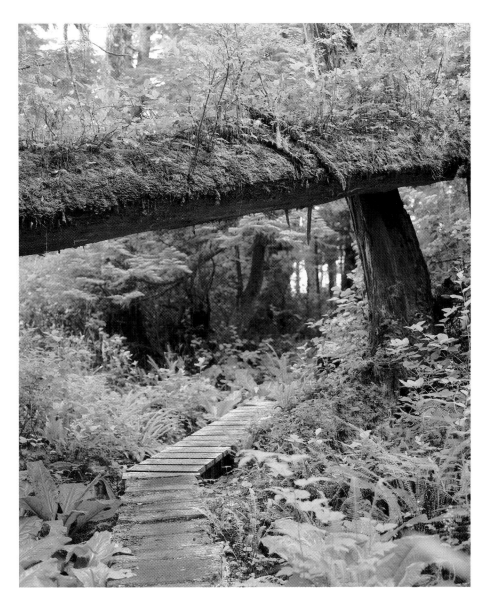

KM.64 — FOREST BOARDWALK NEAR CAMPER CREEK.

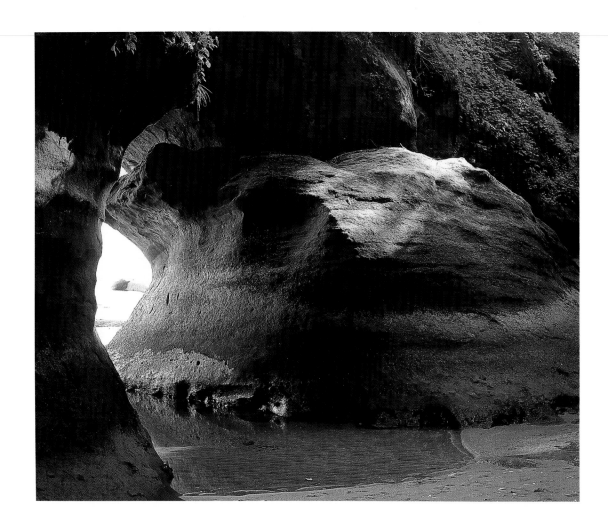

94

KM.67 — SEA CAVES — OWEN POINT.

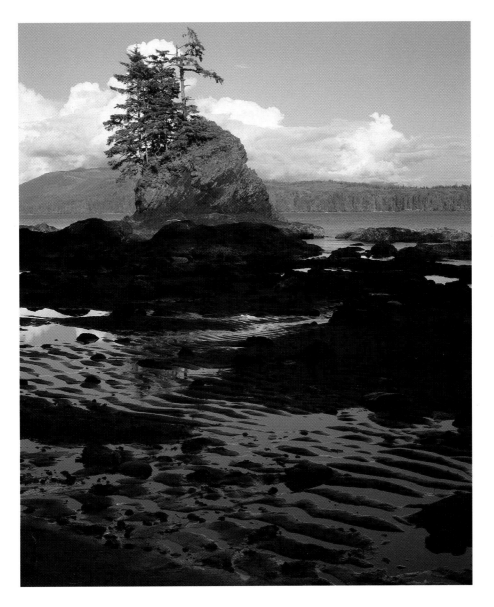

KM.67 — KELLETT ROCK — PORT SAN JUAN IN THE BACKGROUND.

KM.10 — INTERNATIONAL SIGNS AT PACHENA POINT LIGHTHOUSE.

A Trail Album

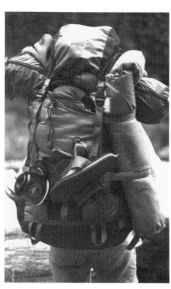 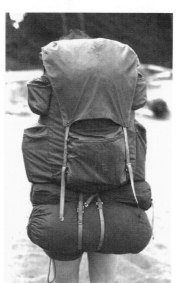 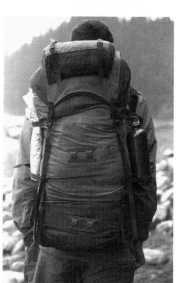

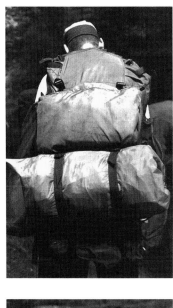

PHOTOGRAPHY NOTES

It is uniquely challenging to carry the photographic equipment required for this type of assignment on top of the gear necessary to support oneself for ten days at a time on the trail — and to carry it alone. Different circumstances demand different sets of equipment. Conditions on the trail affected both what I carried and how I carried it.

The variable conditions of the Canadian west coast require that camera equipment be adequately protected from the wet. I originally packed my equipment very carefully into a waterproof hard case but found it too heavy to carry for extended distances. Eventually, I settled on an extra-large, weatherproof, waist pack with a shoulder strap that I was able to front-pack with the addition of extra straps sewn onto my expedition pack.

All the colour photographs, with the exception of those on pages 13, 58 & 59, were shot with a Pentax 67 medium format camera. The three 35mm colour images were shot with a Nikon FE2. The album 'snapshots' were shot in both formats.

Again, because of severe weight restrictions, I carried a limited set of lenses. These included a 55mm and 90mm lens for the Pentax 67, and a 50mm and a 35 – 135 macro zoom for the Nikon. As well, I carried a set of close-up lenses.

All the images were shot under existing light conditions. A variety of filters were used sparingly to control light intensity, haze, glare, or colour cast under certain conditions. I generally carried a basic filter kit that included a skylight filter, a polarizing filter, neutral density filters, and a warming filter, and for adding contrast to black & white images, a red filter.

With few exceptions, the colour work was shot with the cameras mounted on a Manfrotto 055 tripod with a tilt/pan head.

The colour photographs were shot on transparency film, the black & white work to negative film. Film stock included Fuji Velvia, Fuji 100 Professional and 100D, Fuji 400D, Kodak Ektachrome 400, and Kodak TMAX 100 & 400 black & white.

ACKNOWLEDGEMENTS

Any project such as this would not be possible without the goodwill of countless people. The following, in no particular order, have made this book a reality: Fran, Sam and Lindsay Allen for remembering that there was a fourth member of the family during my months away photographing the trail and the many late nights spent producing the book; Ted and Ursula Allen for their support, accommodations, use of their vehicles, poetry research and editorial comment; Mark Allen for his base of operations in Victoria; Tamsin and Peter Morgana for inviting me on their hike of the trail that led to the idea for this book; Toni and Drexel Moliere; Ashis Gupta, my publisher and editor; Doug and Gwen Fraser, Senior Keepers at the Pachena Point Lighthouse who accepted me at face value on my first visit and were the most gracious of hosts during subsequent visits; Bob and Barb van Sprang, Junior Keepers at Pachena Point for their friendship and enthusiasm; Jerry, Janet, Jake and Justine Etzkorn, Senior family at Carmanah Point Lighthouse who offered me food, shelter and a wealth of knowledge of the area; Kathy Doyle and Ian Colquhoun, Junior Keepers at Carmanah Point, for inviting me into their home for a fine dinner; Rick Holmes, Chief Park Warden for the West Coast Trail, for his generous assistance with permits and information; Ron Hooper, Park Superintendent, Pacific Rim National Park and Howie Hambleton, Acting Park Superintendent, for their help in the planning stages of this project; Kathy Findlay-Brook, Parks Canada Warden, West Coast Trail, for passing along her wealth of knowledge about the trail and the Bamfield area; Carl Edgar Jr. (Wickanninish) and his brother Terry, Nitinat Narrows ferry operators and much more; for letting me stay at their cabin and for showing me a thing or two about crabbing and understanding bald eagles; Chief Jack Thompson of the Ditidaht Band; Esther and Rod; Wiebke Wieland for a cup of peppermint tea on Long Beach at the Cheewhat; Hermann Ott; Michael Puckett, Annette Kyndt, and

Theresa Sheen for a three-day adventure in fine company; Laurie O'Dowd, for her help and encouragement; Tony Vandenboomen for his critical eye over the years; Matt Lambert, Tony Stone photographer, and Kerry, for advice and long conversations about projects like this; Jim Tinios, photographer, for taking my picture; Captain Terry Webber of the Canadian Coast Guard; Celaine Shieck, an excellent pilot, for flying on such short notice; Donnie Noade of Pirate Water Taxi, and Rose Janelle for inviting me into their home and for making Bamfield a better place; Anita, for her fine service at the café in Bamfield; Murray Clausen of the Seabeam Fishing Resort in Bamfield; Ron and Marion Logan of Logan's Bed and Breakfast in Bamfield; Alfred and Ardis Logan, for a fascinating evening with people who have lived the history; Mark Gardiner for his expert editing; Linda Coe and Joe Campbell for their graphics advice; Lyn Turnbull, for her bird research; Darryl Fedje, Parks Canada Archaeologist, and Joanne McSporran; Peter Allen and Judy Breese; a special thanks to Mike Danglemaier, Anders Knudsen, Alex Berenyi and everyone at KARO Design Resources; Jim Beckel of Friesen Printers; Susan Toy of Stanton and MacDougall, Tom Phillips of A&B Books, Calgary, and Colleen MacMillan of Whitecap Books, Vancouver, for early encouragement; and Jim Hamilton, René, Lynn, and Alex whom I had the pleasure of meeting at Carmanah Lighthouse. Last, but not least, a special thanks to all the other hikers who I met along the trail who permitted me to take their photos or who stopped for conversation: Karl Ackerman, John and Peggy Bagshaw, Barbi and Darren Baker, Sam Ball, Anne and Hans Buttner, Klaus Bodingbauer, Ian Burns, Helga Byhre, Victor Chan, Ross Chinchella, R. Chinchella, Adam Chong, Tanya Clarke, F. Cowper, John Davidson, Wayne Davidson, Bronwen Davis, Michael Dole, Claudia Faller, Jennifer Farnum, Betty and JB Hartley, Brooks Horgya, Ken James, Henry Kraynyk, Rolf Kreutzer, Diane Lévesque, Michael Maguire, Bridgette and Bryce McKamey, Chris Morley, Mike Motek, Matthias and Waltraud Neubert, Lorne Newell, Bob Nightingale, Scott Pearse, Dave Phillips, Gail Pollard, Ingrid Rhone, Joyce de Ruiter, Kevin Rutherford, Marianne Schmidt, Wayne Smith, Peter Stanton, Mathias Stiert, Nell and Martin VanderGuchte, Janet Wall, Karri Willms, Hannah Woodley, my friends from Chicago, and to the many others whom I met along the way, a large thanks. **G.A.**

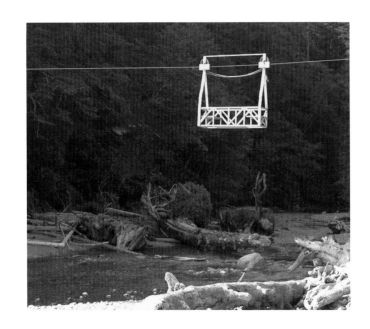

CABLE CAR AT THE DARLING RIVER.

Additional copies of **Timeless Shore**

may be ordered from the publisher:

Bayeux Arts Incorporated,

Suite 240, 4411 – Sixteenth Avenue N.W.,

Calgary, Alberta, CANADA T3B 0M3

Please send a cheque or money order for

$29.95 + $4.00 shipping and handling per copy.

Allow 4 – 6 weeks for delivery.

For bulk orders or for further information call

(403) 288-0170 or fax (403) 288-0170.

The following items, using images from this book,

are available directly from the photographer:

• Professional quality Ilfochrome colour photographic prints

• Printed colour posters

• note cards and postcards

• calendars

Please write or fax for current availability.

4814 – 19th Avenue N.W.

Calgary, Alberta, CANADA T3B 0S7

Fax: (403) 247-6059

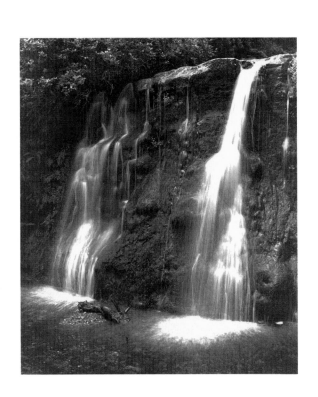